therine,

I hope this next
ar is full of family, fun,
d happy memories Don't forget
o amazing you are, and how
ch you do and care for those
und you. This is a day to
ebrate you and you are definitely
rth celebrating Don't forget to
gh. Thank you for being such a
d and thoughtful supervisor.

appy Birthday! Love, Rebekah Hendricksen

8/26/15

young at heart

young at heart

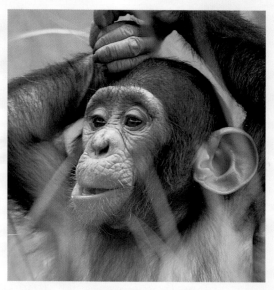

keeping a youthful sense of fun

edited by tom burns

First edition for North America published in 2006
by Barron's Educational Series, Inc.

© 2006 Axis Publishing Limited

All inquiries should be addressed to:
Barron's Educational Series, Inc.
250 Wireless Boulevard
Hauppauge, New York 11788
www.barronseduc.com

Library of Congress Control No: 2005935894

ISBN 10: 0-7641-5986-0
ISBN 13: 978-0-7641-5986-2

Conceived and created by
Axis Publishing Limited
8c Accommodation Road
London NW11 8ED
www.axispublishing.co.uk

Creative Director: Siân Keogh
Designer: Simon de Lotz
Editorial Director: Anne Yelland
Production: Jo Ryan, Cécile Lerbière

Printed and bound in China

9 8 7 6 5 4 3 2 1

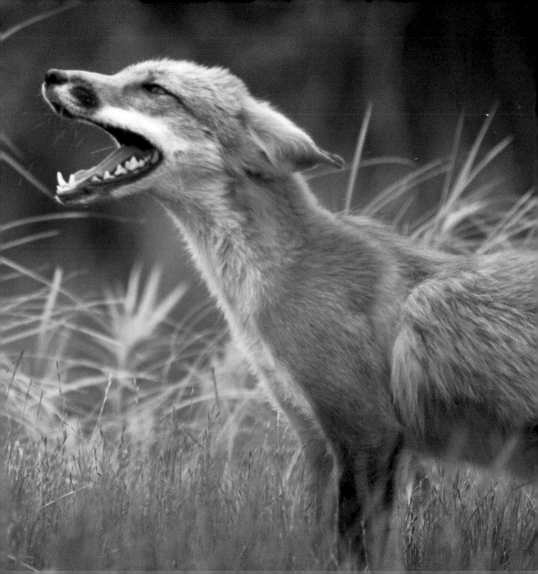

about this book

When you think the world has gone crazy, and there are way too many serious faces around you, reach for *Young at Heart*, an evocation of the glories of keeping the vitality you had as a youngster. Forget your career, mortgage, kids, and hassle, and remember the days you spent doing what you wanted—days that were filled with laughter and light-heartedness.

This collection of wit and wisdom, complemented by amusing animal photographs, will bring a smile to your day and remind you that deep down, you are still the fun-filled, active, forward-thinking, optimistic kid you always were.

about the author

Tom Burns has written for a range of magazines and edited more than a hundred books on subjects like games and sports, cinema, history, and health and fitness. All the quotes in this book were selected from the many hundreds of contributions sent to him by ordinary people giving their real take on life. He has selected a collection that epitomizes why it's important to keep your outlook on life young, lively, interesting, and full of fun.

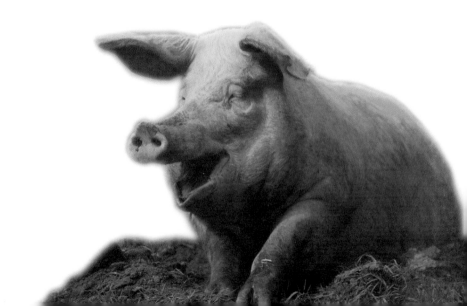

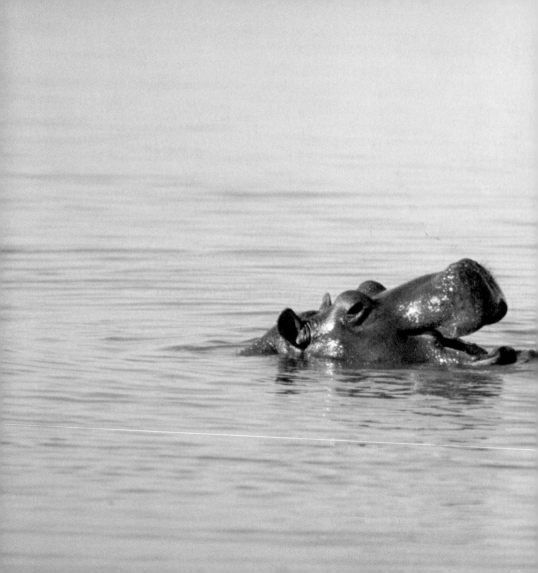

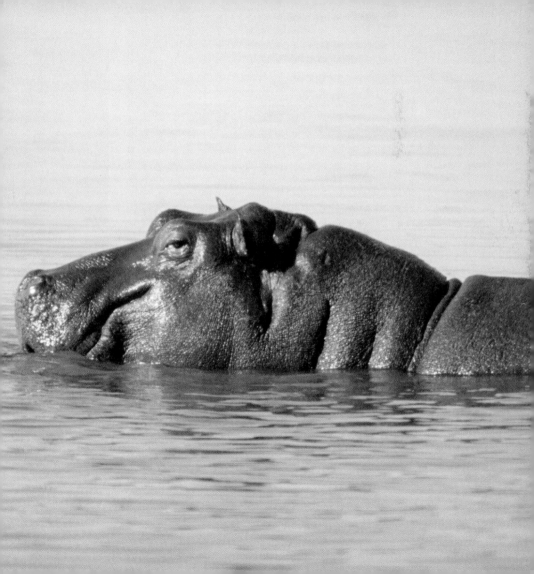

I'm not getting older…

…I collect wrinkles.

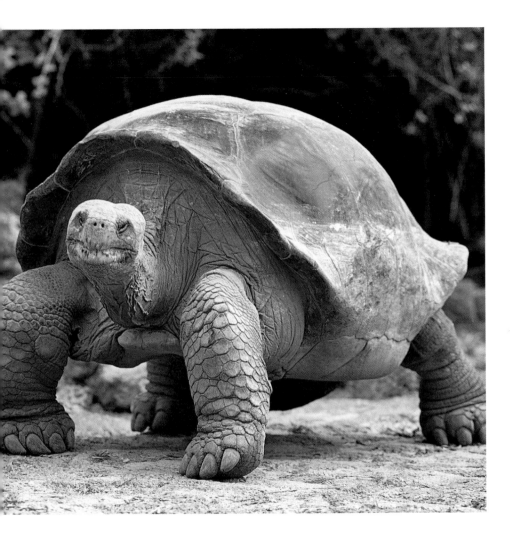

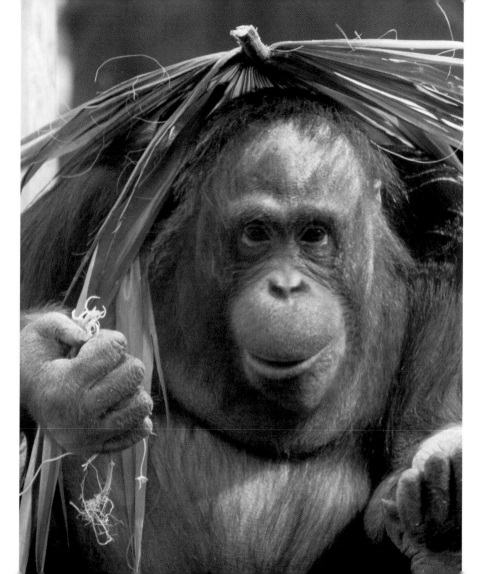

Staying young is about keeping your enthusiasm and forgetting your birthdays.

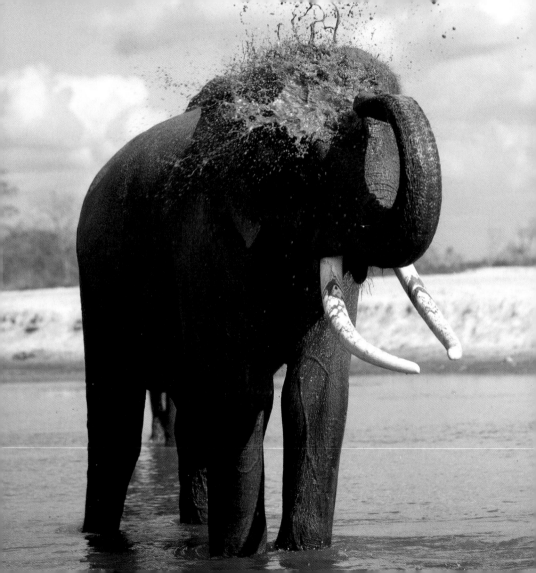

You may not be able to turn back the clock, but you can wind it up again!

Lying about my
age is easier now since
I sometimes forget
what it is.

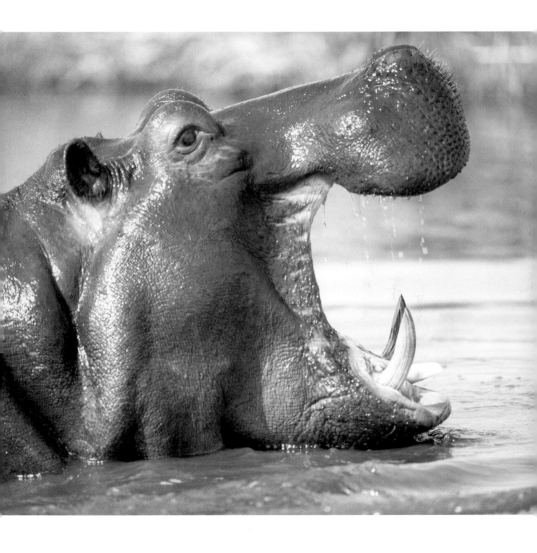

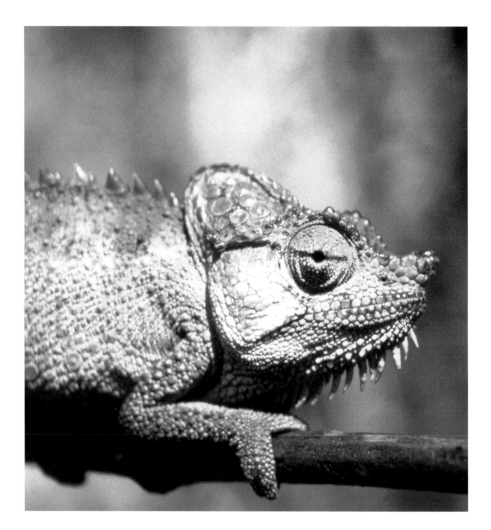

The secret to staying young is to find an age you really like and stick with it.

Over the hill?
I don't remember a hill!

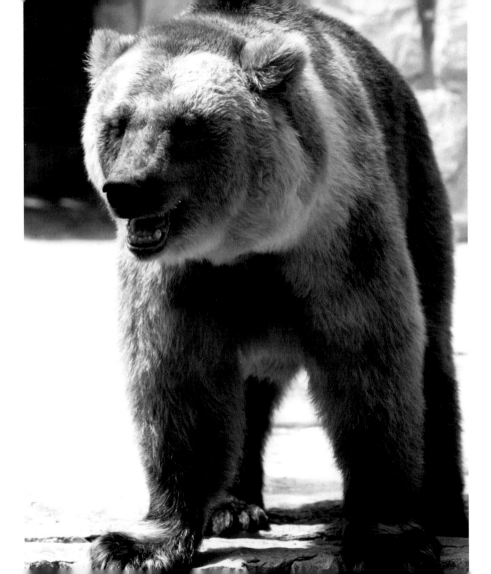

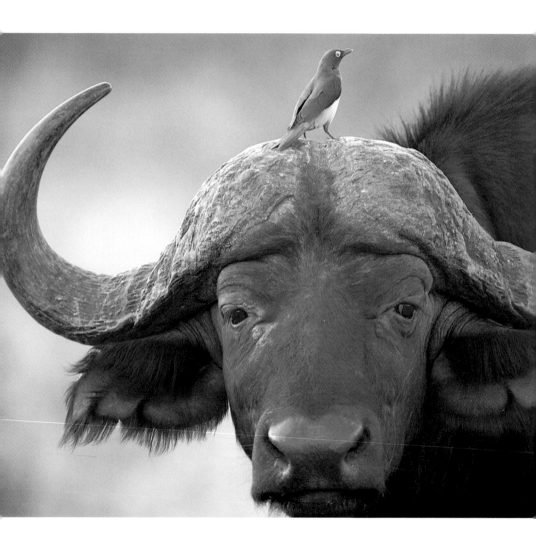

Anyone who is too old
to learn was probably
always too old to learn.

Don't let an old person
crawl into your body.

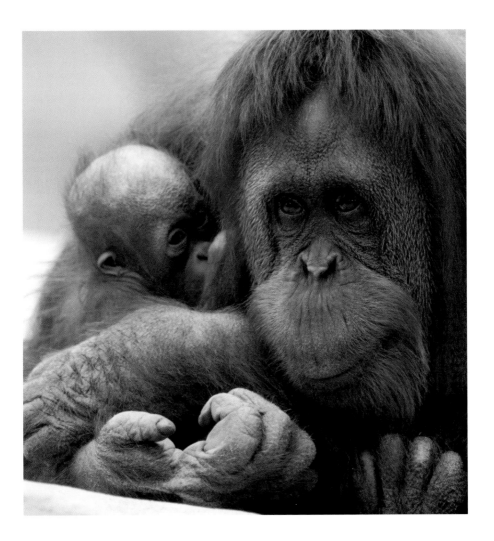

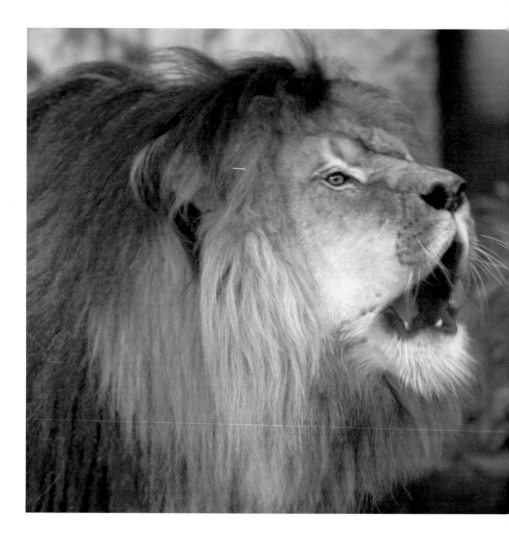

The secret of longevity

is to keep breathing.

Youth is a wonderful thing, but it's wasted on the young.

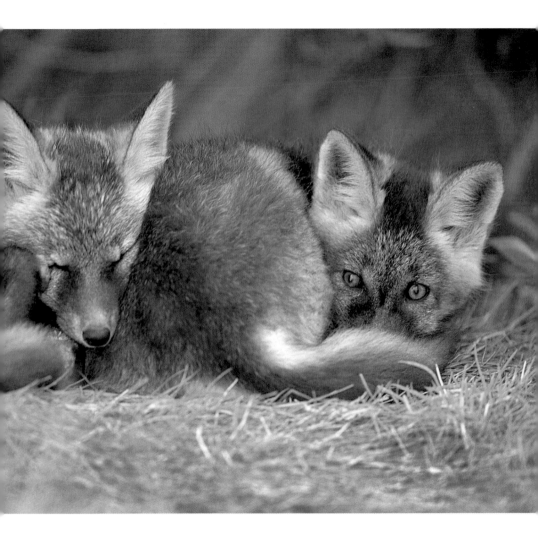

Inflation is when you pay fifteen dollars for the ten-dollar haircut you used to get for five dollars when you had hair.

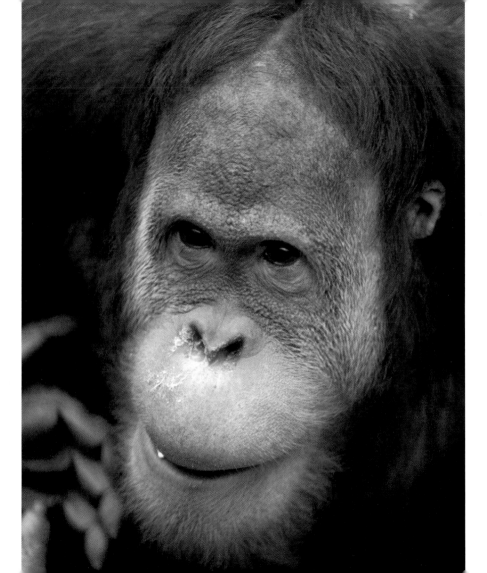

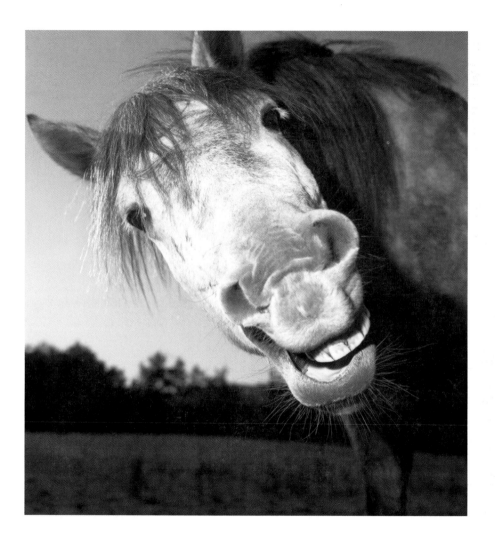

You're only young once…

…after that you have
to make up some
other excuse.

Growing old is mandatory.
Growing up is optional.

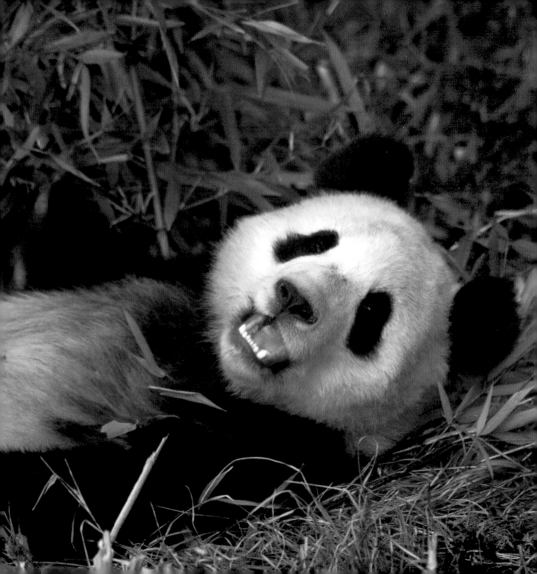

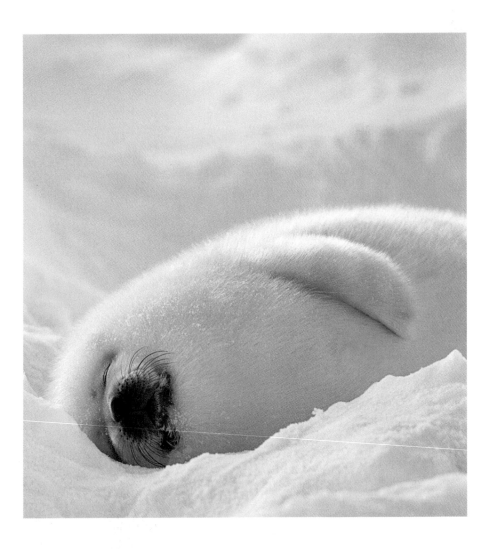

You are only old when regrets take the place of dreams.

Seen it all, done it all,
can't remember most of it.

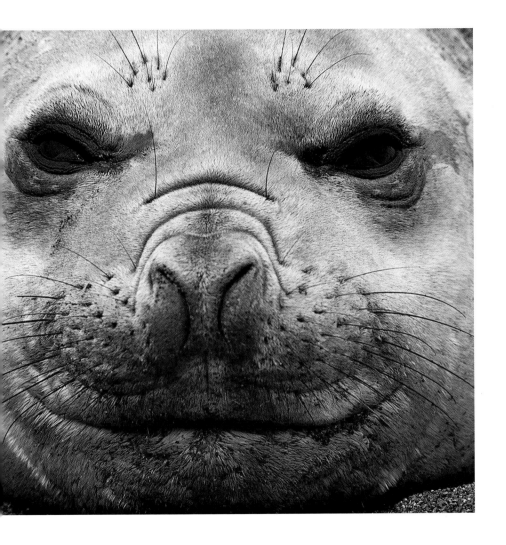

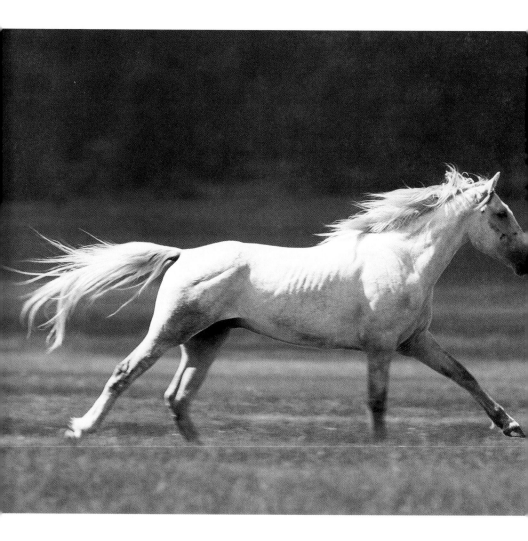

Age is a number;
old is in your head.

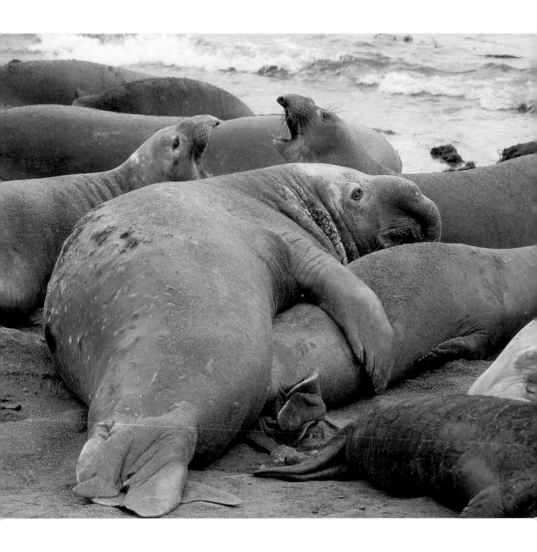

My wild oats turned
into shredded wheat.

Old age is 15 years older than I am.

It's better to wear
out than rust out.

Middle age is when
your age starts to show
around your middle.

I can still cut the mustard—I just need help opening the jar.

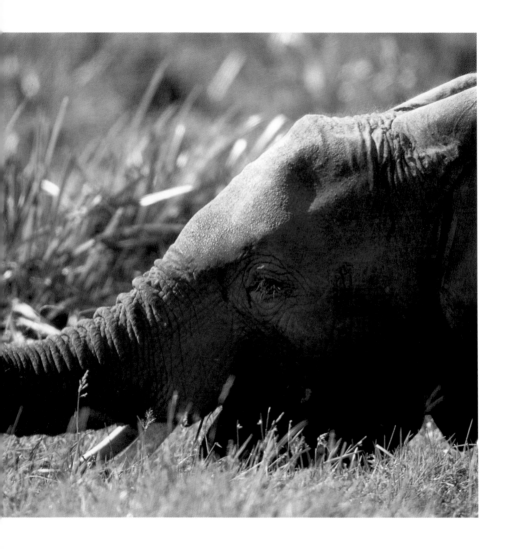

By the time I have money to burn, my fire will have burnt out.

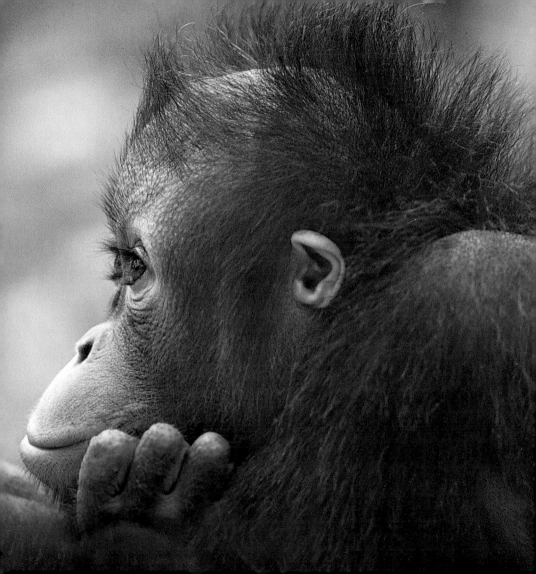

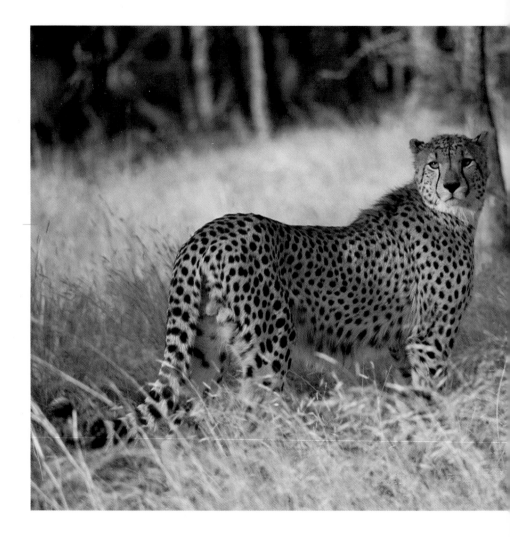

Don't worry about
avoiding temptation…

…as you get older,
it will avoid you.

Nostalgia isn't what it used to be.

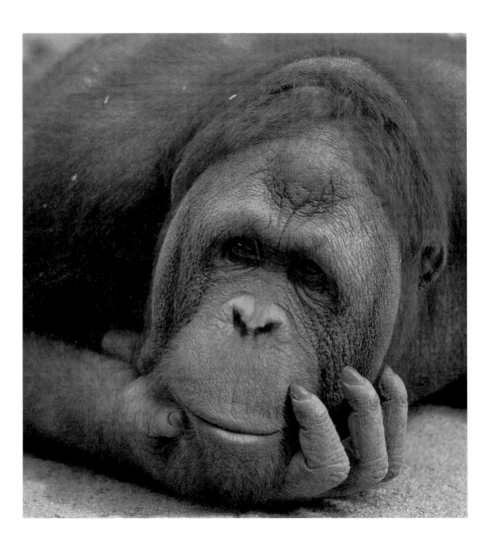

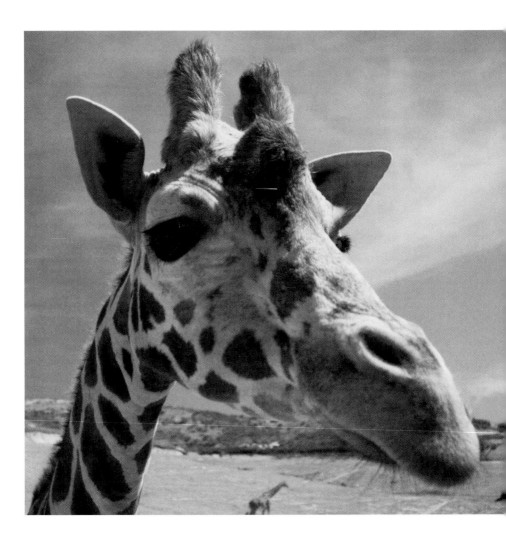

Age is a matter of
mind over matter…

…if you don't mind,
it doesn't matter.

Middle age is when you're too young to take up golf and too old to rush the net.

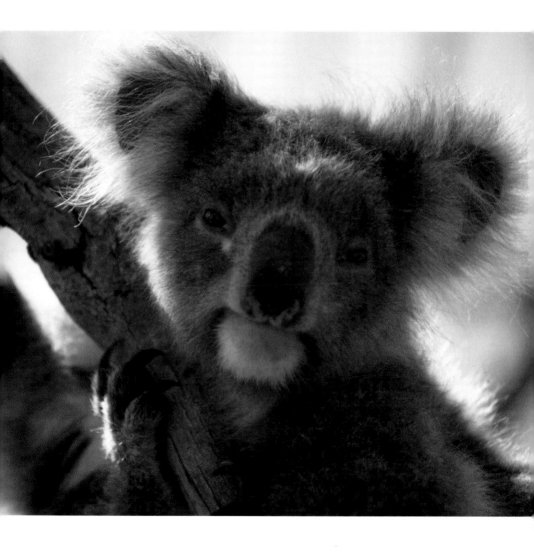

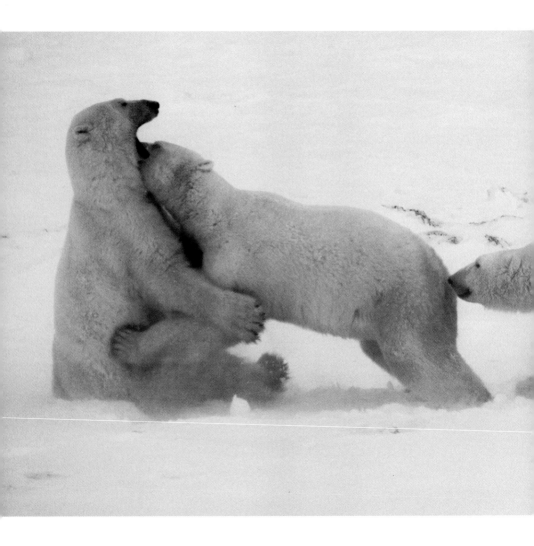

Make every day a holiday
and celebrate living.

It's never too late to be
who you want to be.

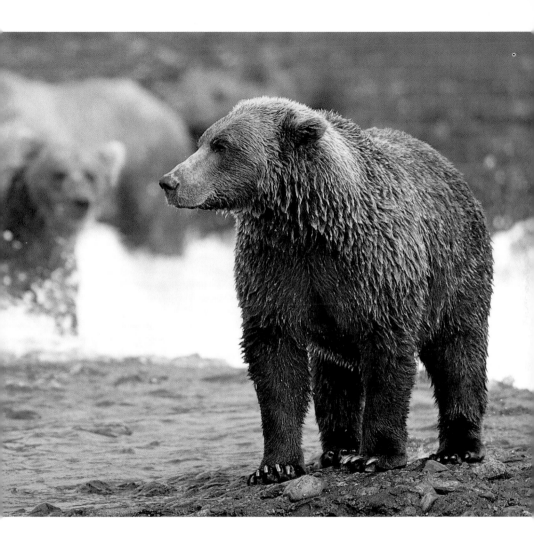

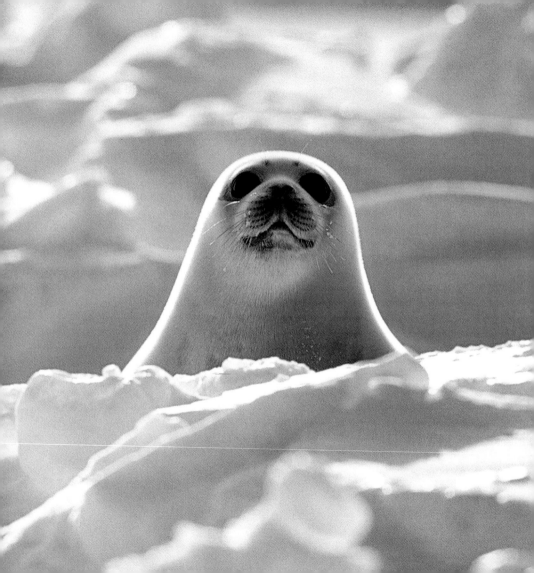

You know you're getting older when you lose the desire to throw a snowball.

Life might begin at fifty, but everything else is wearing out or spreading.

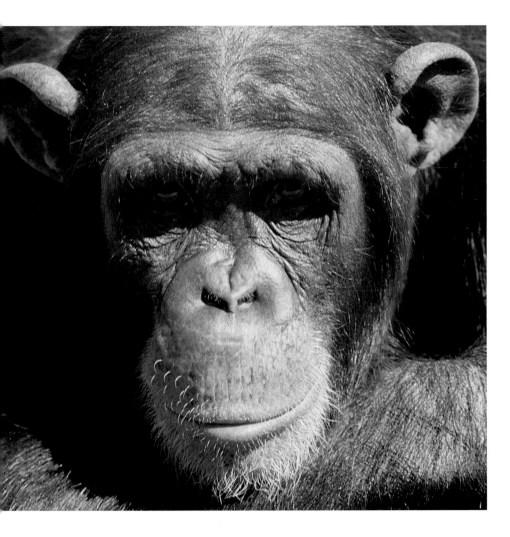

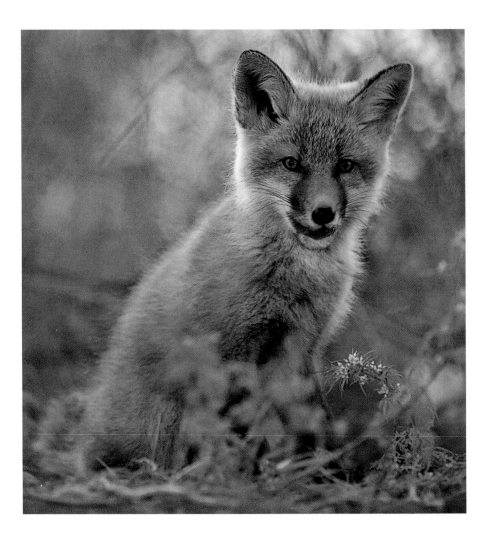

When it comes to staying young,
a mind-lift beats a face-lift any day.

I'm not growing old…

…I'm ripening.

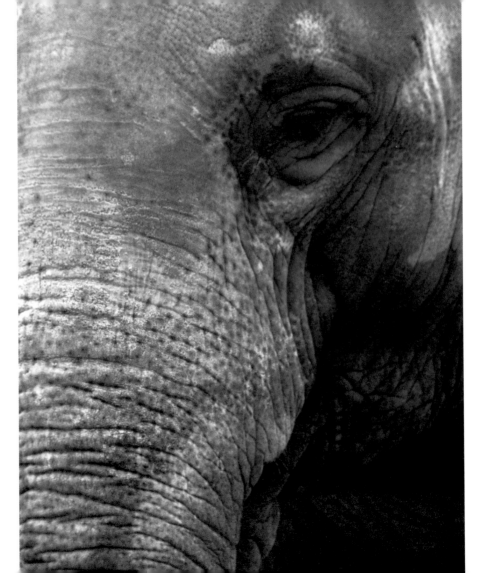

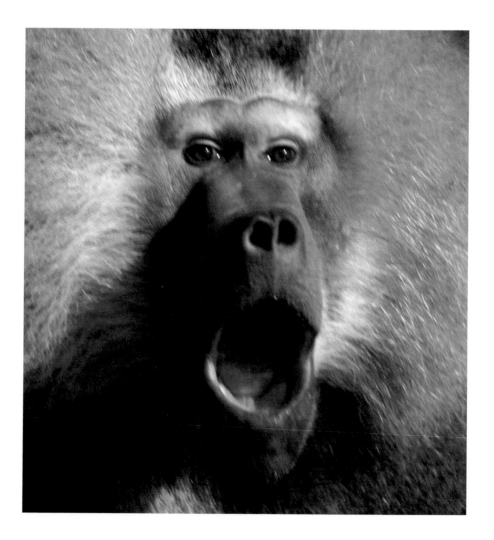

It's surprising how many young fools grow into old fools.

Age is only important
if you're a cheese.

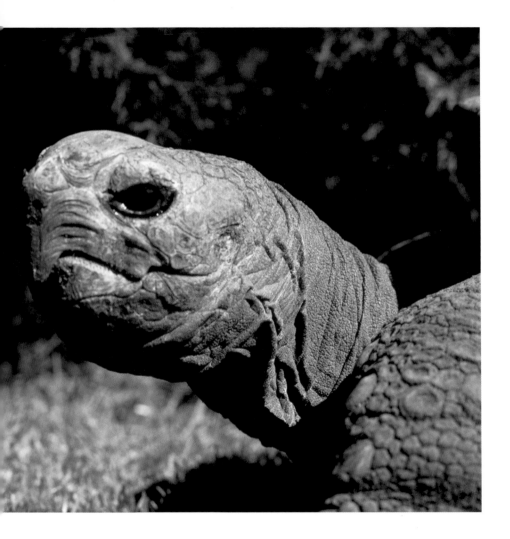

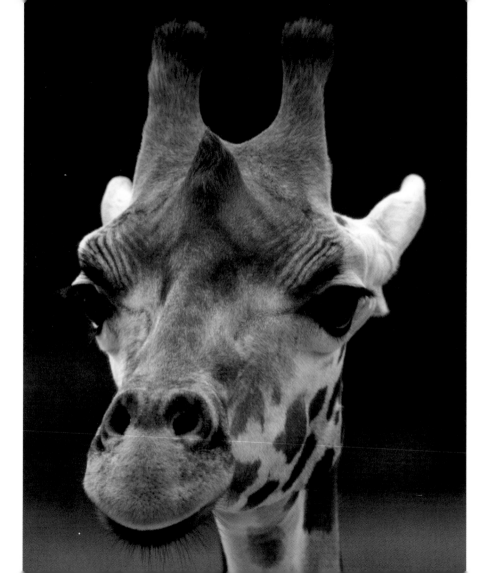

You can live to be a hundred
if you give up all the things
that make you want to
live to be a hundred.

I let my mind wander,
and it didn't come back.

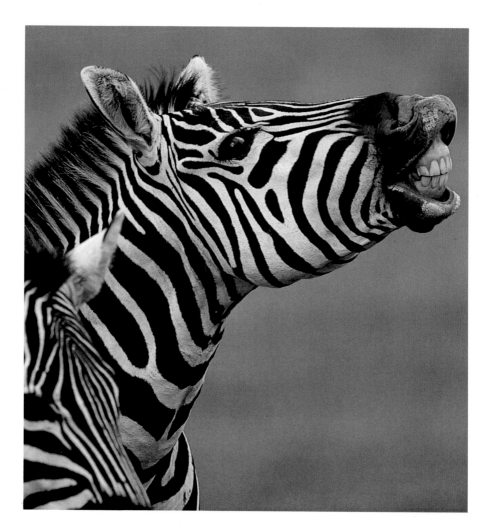

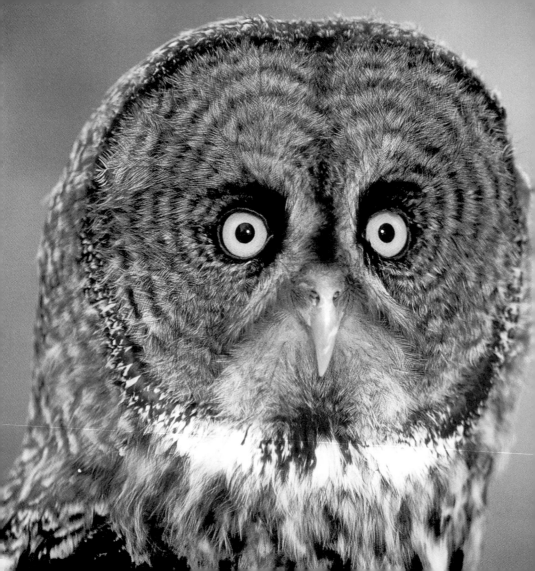

I'm a recycled teenager.

I've been young a very long time.

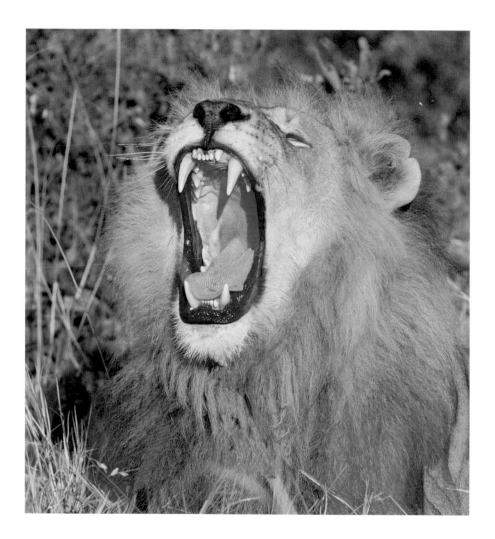

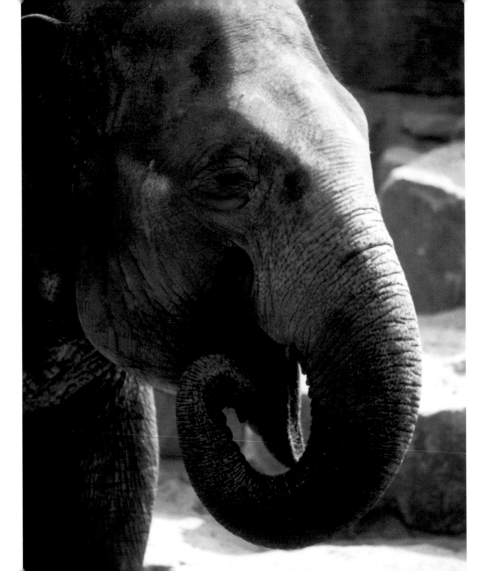

Why grow up when
this is so much fun?

You know you're getting old when the white-haired lady you helped cross the street is your wife.

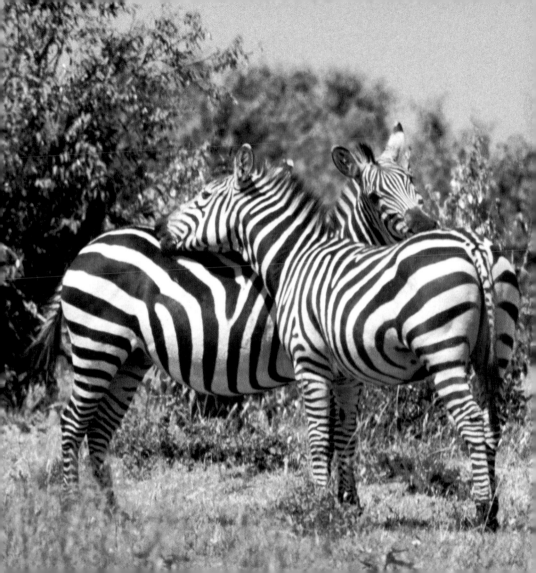

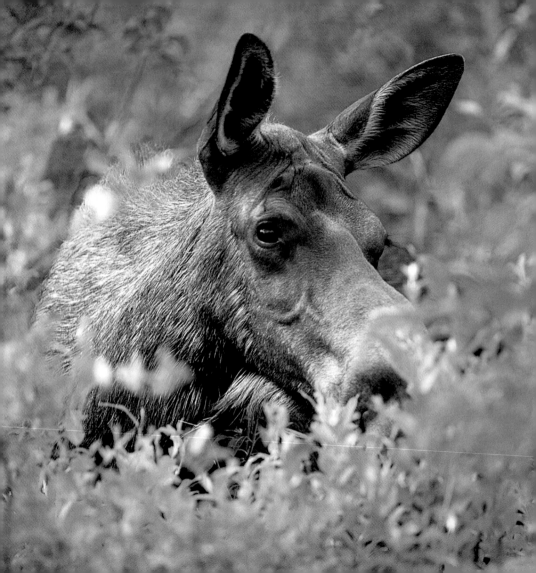

If these are the golden years,
I'm not impressed.

Young at heart,
slightly older elsewhere.

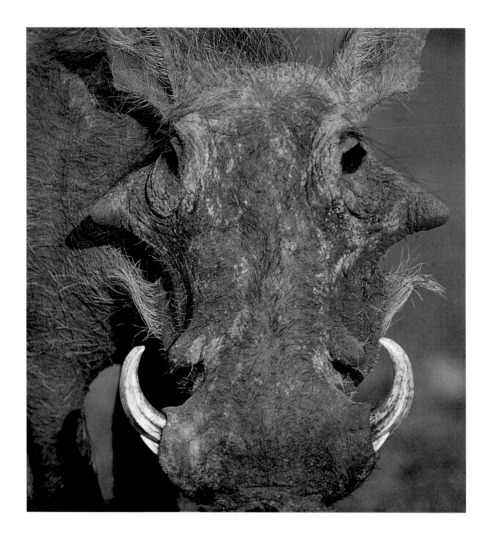

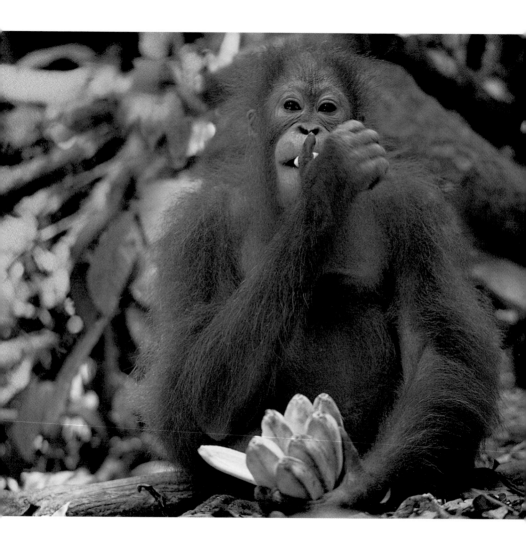

Wrinkles indicate where
smiles have been.

Grandchildren don't
make you feel old…

…the fact that you're married
to a grandmother does.

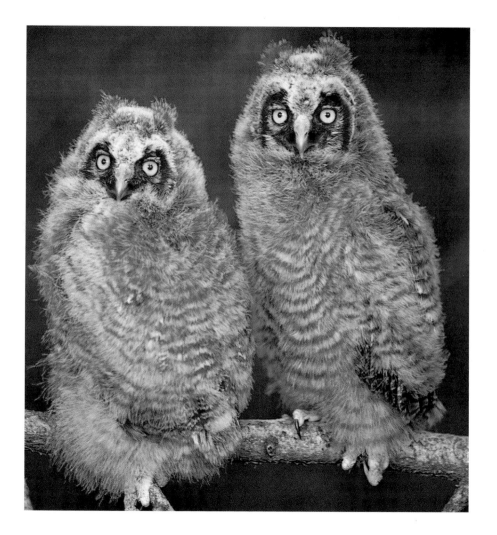

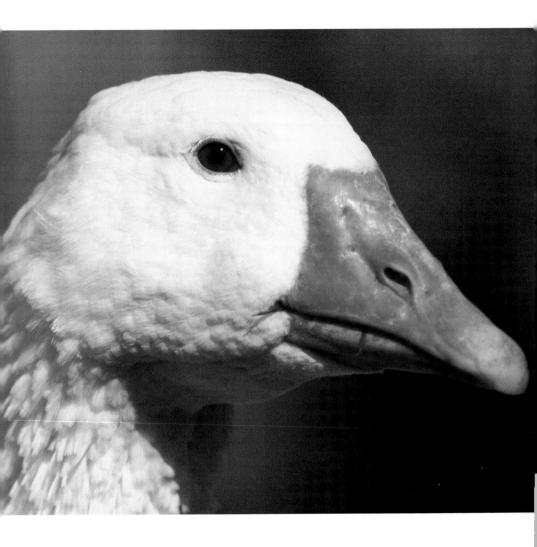

Birthdays are simply
feathers in the broad
wing of time.

Middle age is when you finally get your head together and your body starts to fall apart.

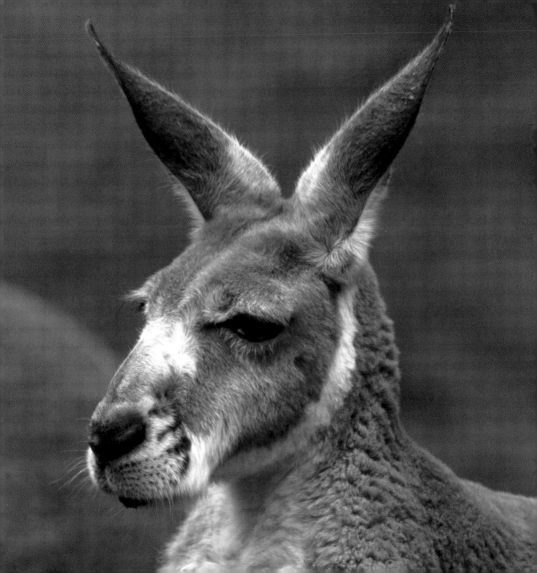

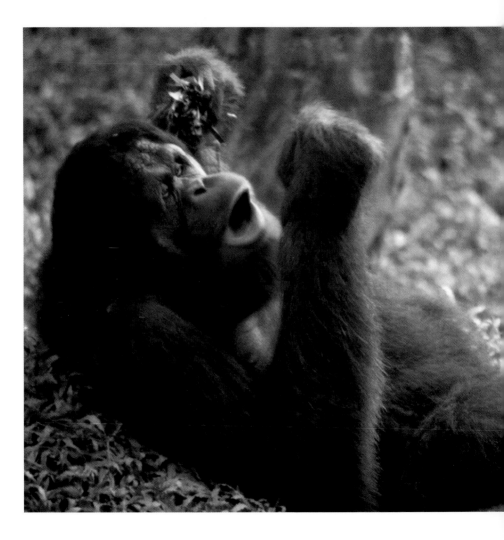

Forget the
good old days…

…what about the
good new days?

What do you mean,
my birth certificate expired?

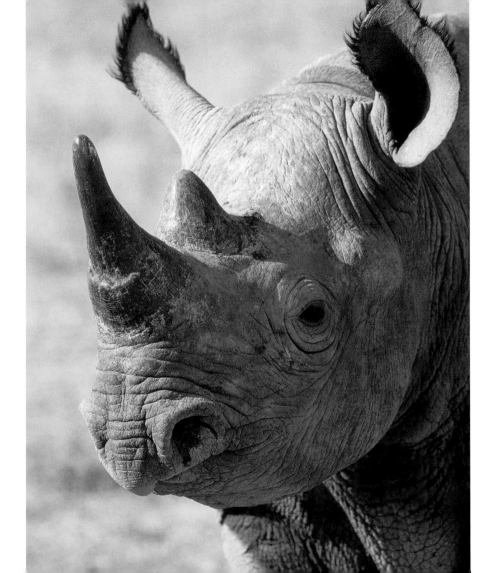

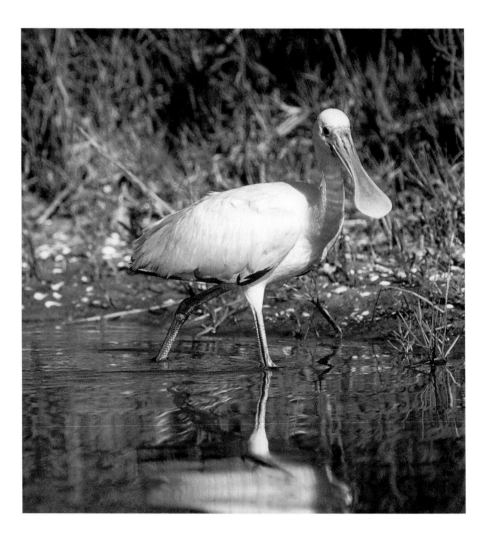

Don't take life too seriously;
you won't get out alive.

Age is a high price
to pay for maturity.

Adults are just kids with money.

The far side of baldness
is a good place to be.

Cleverly disguised as a
responsible adult.

Seventy years young beats
forty years old every time.

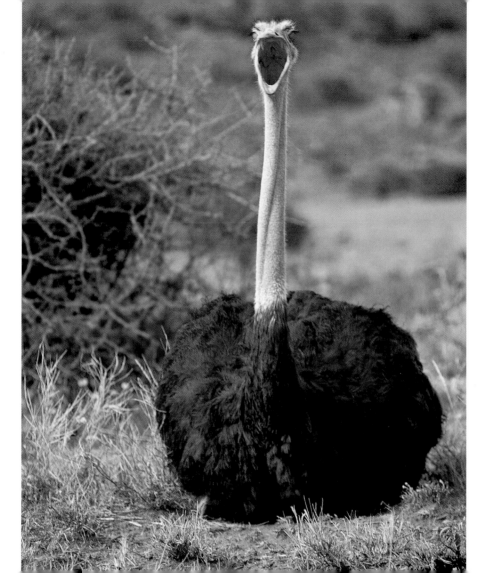

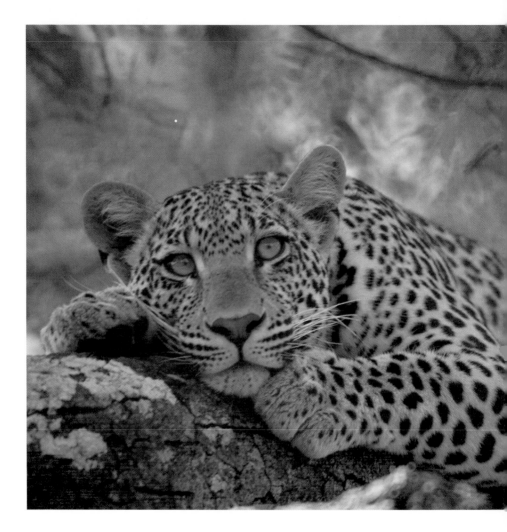

I'm out of bed and dressed—what more do you want?

In a dream, you are
never eighty.

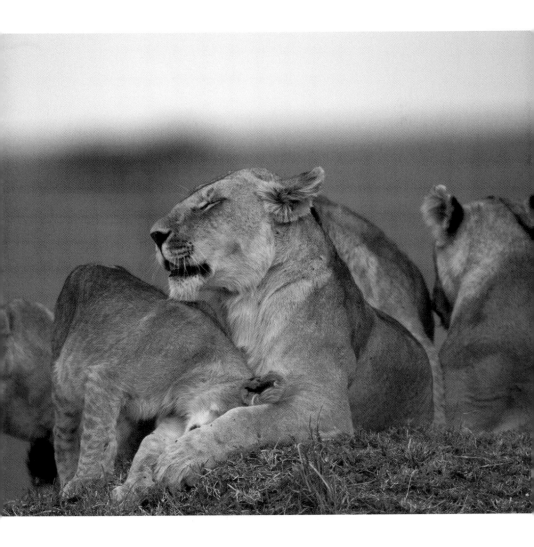

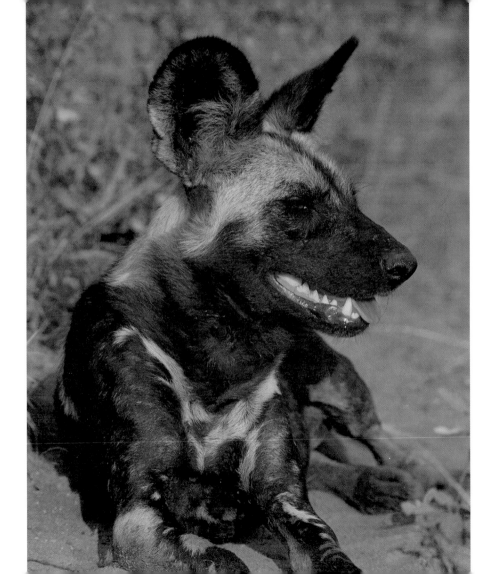

You can't help getting older,
but you don't have to get old.

As you age, everything slows down except the time it takes cake to reach your hips.

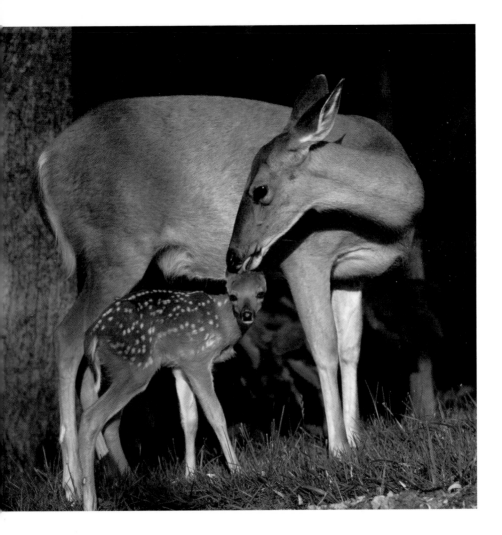

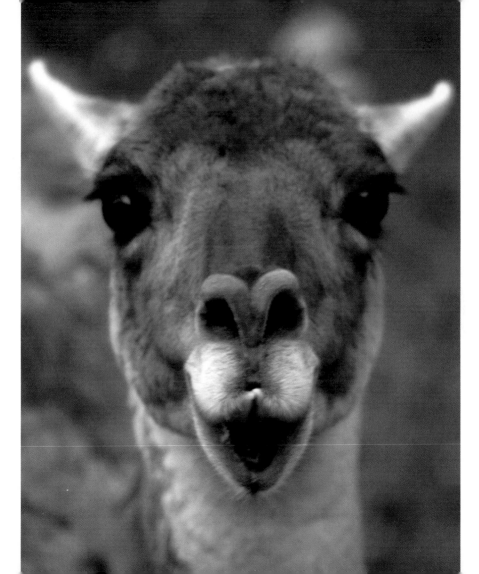

Now is the best time of your life.

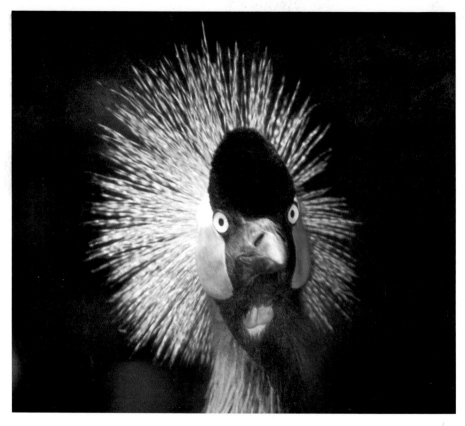

To be old and wise you must
first be young and stupid.